I ate,
I drank, I slept,
I emptied,
I think, I eat, I drink,
I slept empty
I meet, I think, I drink, I eat when I'm not hungry
I sleep, I speak, I think, I drink,
I forget I slept,
I sleep,
 I dream I am empty
 I clean, I share what I've seen
 I lie, I cheat, I always speak
 I spoke, I smoke, I rely on others
 I sleep, I eat, I steal from my brothers
 I lie to my mothers, I hate my fathers
 I want, I see, I hear,
 I feel I am empty
 I fill my stomach, I poison my liver
 I listen, I talk, I seldom walk
 I work, I want, I work, I want
 I question, I take, I take, I want
 I push, I shove, I believe in nothing
 I reassure, I'm never sure
 I swore, I always want more
 I buy, I steal, I never reveal
 I forget Importance

Remember Your Ignorance

I am God
I am man?
I am what I am.

OH TO SEE WHERE YOUR EYES WANDER,

AND IN DOING, UNDERSTAND

THE METHODS IN YOUR MADNESS,

AND REASON FOR YOUR SADNESS.

The Avacado

February 2014, I didn't have a job. The whole month I was trying to keep active, leaving the house at least once a day. I was throwing out my CV like propaganda, repeating to myself, "it's just a numbers game", and it was, something finally stuck. It was the End of February. It was within February that an idea formed and grew in my head. The initial dream was to have a life supply of avocados. I love putting them in my salads, but they are expensive and I was jobless. The only solution? Grow my own plant - then I'd never have to worry about not having money and wanting an avocado. I saw online how to grow an avocado plant, it seemed simple enough: stick the seed in water, give it some sun - and watch it grow. So that's what I did. It was March the 3rd when I saw the first signs.

March 6th 2014

Whilst in the water, its maintenance was easy: change the water every now and then. It really started to take shape by month four. I named it Janice. On June 9th 2014, I moved Janice from her half-pint glass into a large pot of soil; She looked so small and dwarfed by her new soundings. Being impatient I brought some "Grow Helper" to help her grow faster. Now, I knew that it would take a fair bit of time for Janice to produce any fruit for me, but I was fully prepared to grow this plant for as long as it took.

By July her long leaves started overshadowing leaves growing underneath. I wanted to encourage new leaves to grow , and I developed this habit, which in hindsight I think was a bad one: I started pruning any leaf that started getting too big. In the beginning it seemed to help, but the stem didn't seem to be growing and I wanted it to grow. When August came around I started to see signs that Janice wasn't doing so well, she had stoped growing completely and her leaves were losing their green.

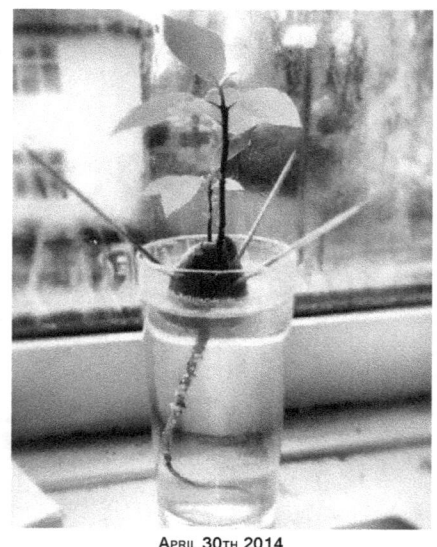

April 30th 2014

I began to wonder whether I should just try growing something easier - like chilli or something. Then the idea about the consciousness of plants got me thinking about how morally right it was, in my heart, to continue to keep Janice alive if I had completely given up on her. As I stared at Janice in a perplexed manner, the memories of the true scale of time that I had put into growing her: it hadn't taken up much of my time per day, but I hadn't kept anything going for that long before so I was proud of her.

July 6th 2014

I imagined myself holding the seed and giving it a firm tug pulling it from the earth. That would be the end of it. It would go in the bin and I would move on. I couldn't do that, so as a final "Hail Mary", I cut off all the dying leaves and carefully pulled the seed out by the roots, dug deep into the mud so that they would come out safely and intact. I heard some tearing in the lower parts of the roots, but as a whole Janice came out mainly unscathed. I gave the earth a drink of water and left it for 24 hours.

March 6th 2014

It was September and she was growing again. As Janice sits next to me as I write this, I still can't help but think it would be so much easier to grow and a different food, and perhaps I will.

But what I have come to realise is that when it's my choice, I find it hard to give up on something in which I have invested so much time, and that's when I started thinking about my ex-girlfriends and all the ambitious expectations we had; how easy I had thought it all should be - how easy it was in the beginning, how I started to see those relationships die; and how glad I am that it wasn't my choice whether or not we stayed together, because like with Janice, I can't just kill it.

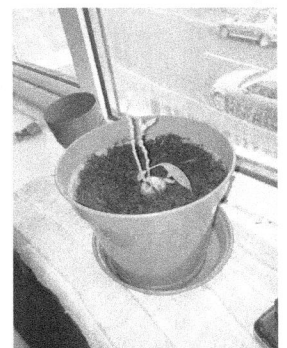

September 16th 2014

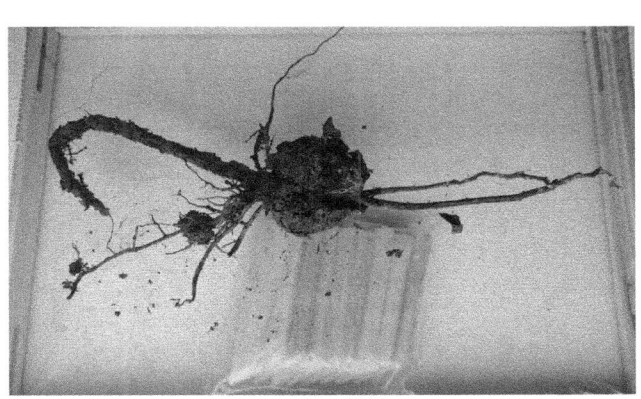

January 30th 2015

Hindsight - November 2015. Before I moved to London I threw Janice away. Since then my girlfriend has told me that Avocados hibernate in the winter as they are tropical plants, so it may have grown again. I was obviously mentally ill-equipped to get that plant to grow. It's sad, but after a year of not having it growing on my window-sill I see with clarity that, like with many of the relationships I've had and lost, if enough time goes by, I forget, move on, and chalk it all up to a learning experience.

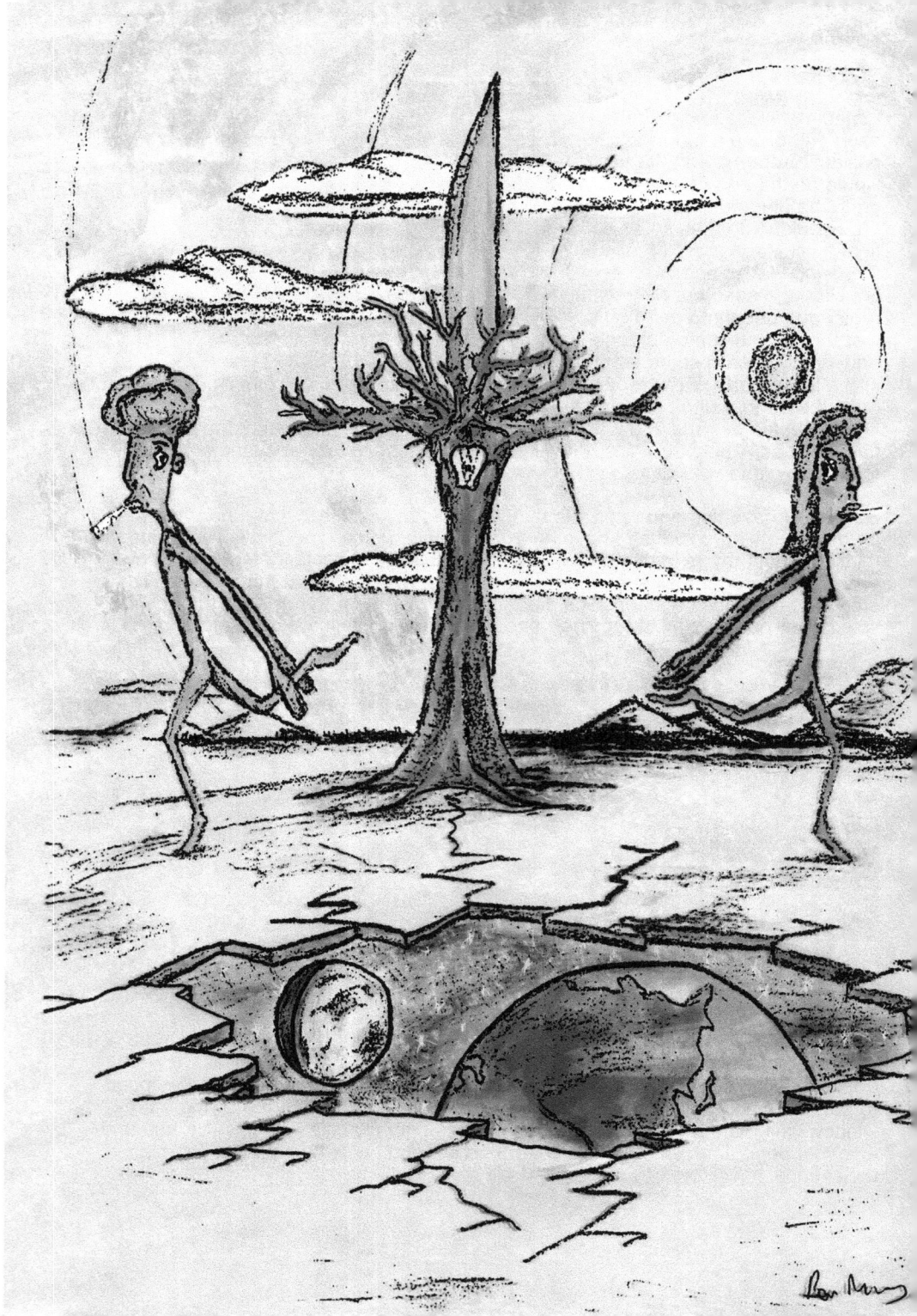

Eve and the Devil: The Neolithic Revolution

"Hey girl you're looking a bit famished
you've had your fun, now your garden's a bit damaged.
Your running out of natural resources,
looks like you don't have a lot of choices".

"But didn't you notice
or did you know this?
by looking at the seeds,
of that forbidden tree".

"All you need is water and some sunshine,
hard work and a little time.
Then you can eat when ever you like,
you and I both know that really does sound nice".

"Didn't you notice?
Now that you know this,
you should go tell Adam,
it will really impress him".

"Now that you've more food than you need
you could find others and trade
but don't go doing business with your bits out
it's something you might want to think about"

"But didn't you notice
well you should know this
that men will take the credit
and then blame you for it"

ONLY BEFORE BED DO I TRY TO RHYME IN MY HEAD.

Undoing the two things,
while the ruling, drooling masses cling together on a narrow thread,
threatened by the ability to try
anything not done in line with what's already been said.
I fled to a lonely corner
as the bodies grew colder with every price cut,
until the waiting bodies were wading through trolleys,
in a failed attempt to keep up with the Jones's.
This is the end of peasants rising up against their lords,
'cause now they can afford
comforts that turn them to mush,
and forget they all have grey stuff in their skulls.
How dull it is to hear the business of others not around
and yet that is all I hear when my ear is to the ground.
I'm forgetting what it means to see further than a road,
I'm losing all those human things, like having a moral code,
And so I move on my want,
and leave that little bit of grey matter
scattered on my nose.
Egyptian death.
well I impressed upon a single soul,
who didn't think to have a drink before heading for the cliff.
Differences aside,
I cannot hide
the fact
that I don't know how to act.

So I stand like a statue until someone notices.

TREEMAN

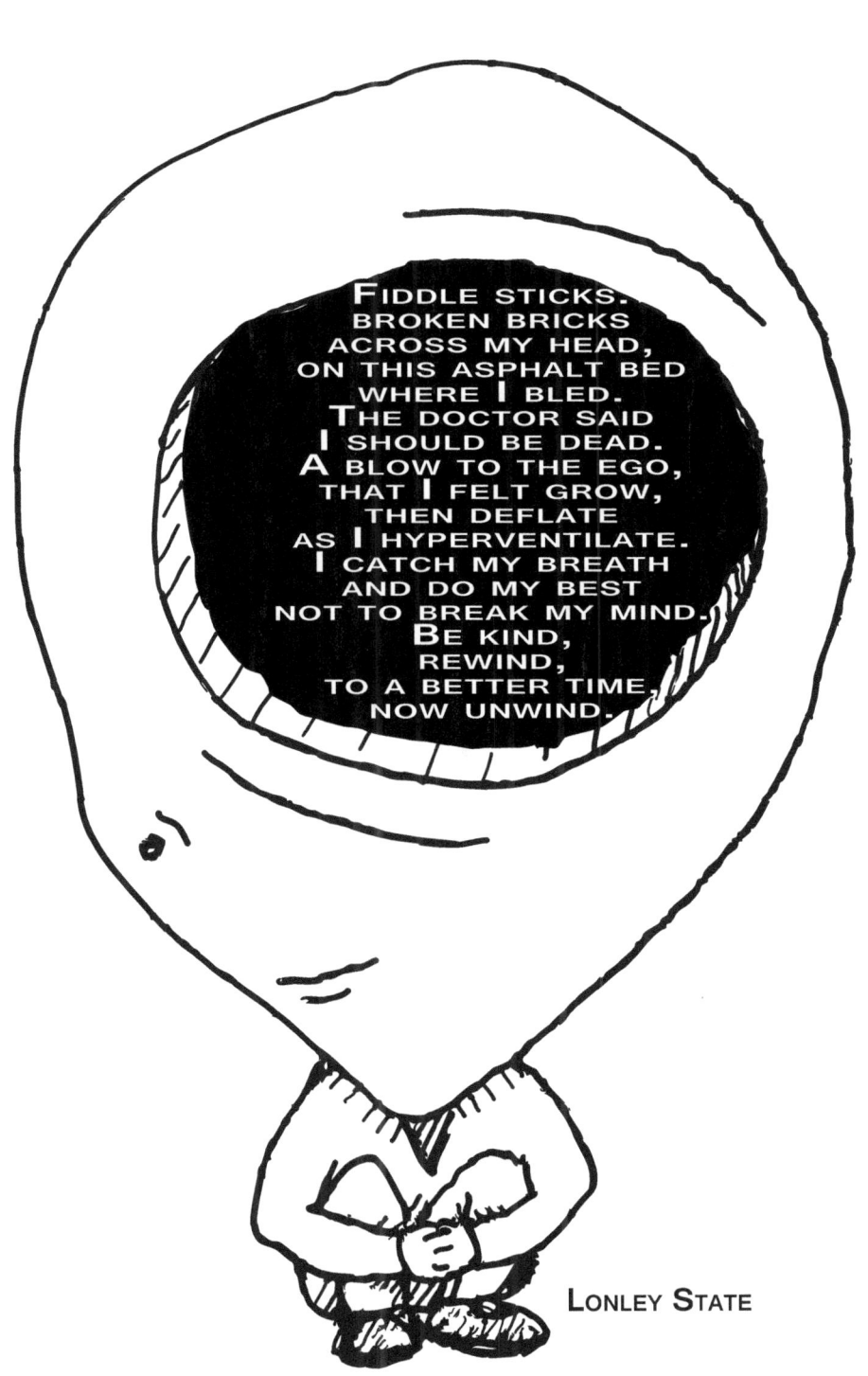

My Dream of a Turtle

It started how every dream starts, all of sudden and all at once.

I found myself on a beach in Australia, I have never been to Australia and wanted to go to the Sydney Opera House. But there was the beach, and the sun was out, so there I stayed, partly to watch the end of a marathon taking place. The race was coming to a close, with the majority of participants exiting the water with the sun on their backs.

As I watched the athletes cross the finish line, and culminate with their signature "end of race dance" routine, I noticed one man limping. I followed him with my eyes, trying to work out the source of his injury.

Once he had crossed the finish line the crowd dispersed as he fell to the sand, and a snapping turtle jumped off his left leg where it had been biting down. It got up on its hind legs, looking worried and scared, and making a B line for me, scurried up my body and held on to me tightly. At first I was afraid of this foreign creature holding on to me, but its size, and presence on my chest reminded me of a baby who just wanted to feel secure. As these maternal feelings washed over me, the creature morphed from a snapping turtle into a human baby.

Forgetting the turtle, I focused on keeping this baby safe, which must have angered the turtle – now a separate entity and whose essence must still have been roaming in my mind – for out of nowhere it bit the baby on the finger and would not let go. In that moment I was both the baby and the parent, terrified of the pain lasting forever whilst at the same time angry the baby was feeling pain at all.

With this fear and anger in my heart, I clenched my fists and started to repeatedly punch the turtle in the face. I think this action stemmed from a story I had heard years ago, a woman who was giving her man fellatio, had a seizure and got lock-jaw and the man's only recourse to get her to let go was to repeatedly punch her in the jaw.

Impulse Ready, Body Shocked

This repetitive violence did slacken the turtle's jaw long enough for it to let go of the baby - who then disappeared as bizarrely as it had appeared - but the turtle then fixed its jaw on my hand.

A swinging battle ensued where I found myself spinning around as fast I could, hoping that the turtle would let go. The force from being swung was enough to pry its jaws from my hand, and in doing so the turtle flew across the crowd and landed squarely and securely on my friend's face.

This was the final straw, my anger exploded from my chest, coursing through my fists and depositing on to the turtle's face. He continued to get in some good bites but by the time I had regained composure the turtle was bloody, beaten and bruised within an inch of his life.

Remorse flooded through my body as I picked up his fragile remains; my eyes scanned the crowd then back to the turtle as it coughed up some blood.

"Is there a doctor in the house?" I cried, but there was no response from the crowd. They all stood there staring at me through their phone screens, as they captured the entire ordeal from multiple angles.

I ran along the beach, searching for anyone who was medically trained. Finally, after many disappointed shakes of heads and disinterested hearts, I found a vet willing to take a look at the turtle.

Placing a stethoscope on the turtle's chest and checking his pulse, the vet shook his head and said, "There's nothing I can do I'm afraid, this turtle was dying before you attacked him."

It seems he was suffering from alopecia and would shortly be dead, so I gently took the turtle from the vet, who left us to say our goodbyes.

So under the Australian sun, with the waves crashing and the distant sounds of frolicking, I made my peace with the turtle. I told him how sorry I was for letting my anger get the better of me, for not trying to understand him, and for making his last moments in life full of suffering and pain.

The turtle turned its head towards me and with what seemed like the last of his strength, smiled and told me not to worry. He whispered, "I have lived for 450 of your years and in that time, a day is nothing but a minute."

In that moment I comprehended time on a massive scale, I experienced change over centuries, and the fleetingness of my own existence. My chest started to overheat as it tightened, the pressure built up to my throat. I swallowed as the heat shot into my eyes and two tears dropped onto his shell.

The turtle coughed up some blood as it continued, "Life is its best when the soul's at peace, but is just as good when something unexpected happens."

With that the turtle died, and I started to wake up. In my final moments of leaving the dream, I felt so guilty for fighting the turtle. I started to think the vet had just told me what I had wanted to hear, to make me feel better.

As my eyes opened and my body awoke, my mind did not - It was still thinking of the turtle: so to justify the entire ordeal I told myself he looked like Kron the bad guy from the film, "Dinosaurs" (2000).

Groggy Boredom.

Fresh out the box here's your new skin.
Weathered and soaked, whether or not we choke it down.
Stifle my grin, at questionable sin. Text,
concepts flying overhead, whirlpools in thighs,
as working tools lie on cold cobblestone floors,
and meet the cheek that overheats when eyes run up the skull.
Then Fear multiplies as ten thousand knives cut and become dull.

I never learned to speak out my mouth
but my ass has found a voice
and takes away my choice of chosen words.
So hide me in the suburbs,
change my face and teach me grace
with a ninja-like movement, formed from stars.
I'm scared of cars so I stay on the pavement,
shoes tightly glued to the asphalt.
Insurance man, I'm sure I can pay that monthly fee.
Attention fails as I see the tail fade from the car that hit me.
Black and white is all that's left: As pain turns to white hot heat,
then thoughts go dark and fall apart, as I turn into dead meat.

Stubborn Impulse Trigger

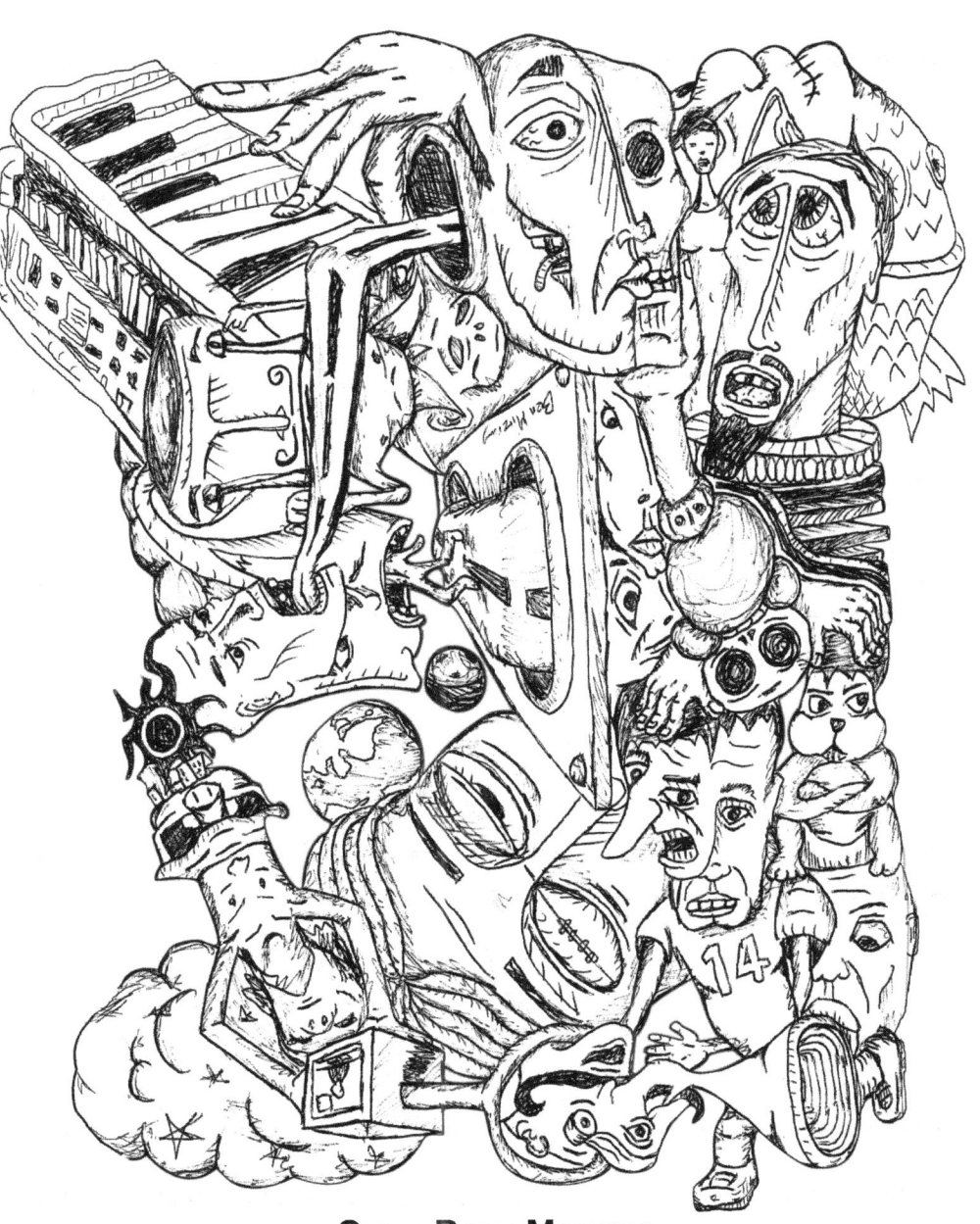

CLOAK ROOM MADNESS

I SPEAK THE PAST TENCE, I FEAR WHATS BEYOND MY BACK FENCE

STRANGERS AND DANGERS
AND IGNORANT WANKERS
FAKERS AND JESTERS
PERVERTED MOLESTERS
COOLER ARE THE LOSERS
AND ALCOHOL ABUSERS

THE GOLD MINING USERS
AND VACILLANT CHOOSERS
THE UNDER ACHIEVERS
THAT STEAL OFF TAX PAYERS
THE SECRET KEEPERS
LAUGHING AT BELIVERS

YOU'D KILL FOR A MIND WIPE, ANOTHER CARD TO SWIPE

ANOTHER NUMBER TO PUNCH IN
BUT I FORGOT MY CHIP AND PIN
ANOTHER WRAPPER IN THE BIN
EVERYONE PREPARE TO SIN
ANOTHER MILLION TO WIN

ANOTHER LIE UNDER A GRIN
ANOTHER BEAUTY WAY TOO THIN
ANOTHER COW HAS DOUBLE CHIN
ANOTHER CRIME BECAUSE OF SKIN
ANOTHER CRIME IN THE KITCHEN

THE CAT CAUGHT MY TOUNGE, I COUGH UP A LUNG

IM A SMOKER
A JOKER
RUBBISH AT POKER,
NOT A SMOOTH TALKER
AVERAGE SPEED WALKER
ALL SORTS OF CANDOUR
UNIQUENESS IN LAUGHTER

NOT A GOOD DANCER
A RISK OF GETTING CANCER
I DONT KNOW AN ANSWER
TO CONVERT PASTOR
NO OBVIOUS ORDER
AND IM ALWAYS GROWING OLDER

GET KICKED OR LEAVE, I DONT KNOW LETS ASK JEEVES

WHAT'S WRONG WITH MY PREDICTION
WHAT'S WRONG WITH MY ADDICTION
WHAT'S WRONG WITH THEIR FIXATION
WITH BRUTAL MUTILATION
WHAT'S WRONG WITH MASTURBATION
WHAT'S WRONG WITH PROCREATION

WHAT'S WRONG WITH TAXATION
ON THE FAT IN THIS NATION
WHAT'S WRONG WITH TERMINATION
AND GLOBALISATION
WHAT'S WRONG WITH DOMINATION

HELLO, I AM HUMAN

ME THE LOST WHALE.

Jump, Run, Walk, Swim in a pool.
Cool
I will.
I have nothing better to do.
Good, foolish feelings, growing and dreaming.
Apologize now.
You will,
after making demands so grey and toneless
It makes me hunger for boredom.
Your explanation turns me speechless.
Senseless words drip and drop from your tongue,
then spit, flip and flop.
Up, down side to side.
Spraying and flailing around and around. Like a hound
with food stuck to its tail.
Or a beached whale on a beach full of seals,
making diamonds as they grind their teeth.
"It's payback time for all those babies you try to eat."
I drift away
'cause my throat can't say what my mind can't comprehend.
I see the table through my hand and slowly now I understand.
I had a watch in my side,
taking notes as I toked down some smoke.
When I choke, who will save me?
Why would you save me?
I've done this to myself. So leave my ashes on the shelf,
or in the cupboard, where it's hard to find .
Because when I'm out of sight, I'm out of mind.
But then,
to be in your line of sight, but still out of your **head**
would send me spinning for an **age**,
until my stage is empty
and there is nothing left **inside me**.
But behind me, an angel
-with a tongue made of gold which
she sold
for one pound fifty.
Please,
you're worth more than that.
At least double that.

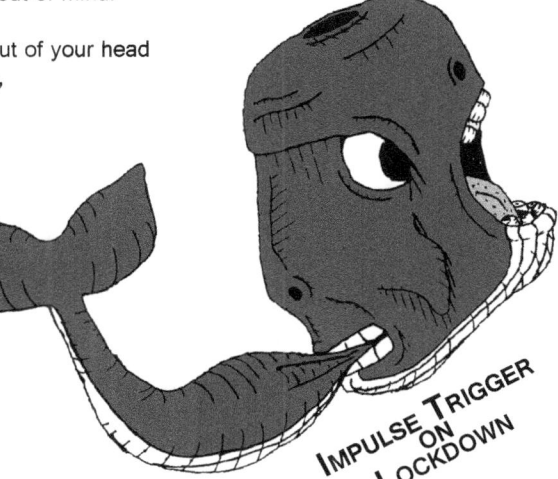

Do Feelings have Titles?

In another minute I'll be dirty. But surely
she'll be dirty too?
Open your hips between my lips.
It starts with a kiss and ends much too quickly.
Maybe this was meant be.
We'll wait and see.
In the morning, after yawning, there is a gnawing in my gut
as I fall in the same rut that comes after pining.
Then finding my void is still empty and yet her's, so full.
In another year I'll be nearer thirty, closer than I've ever been.
And yet I still have not seen eyes or mouths
mouthing the meaning of words I give away so freely.

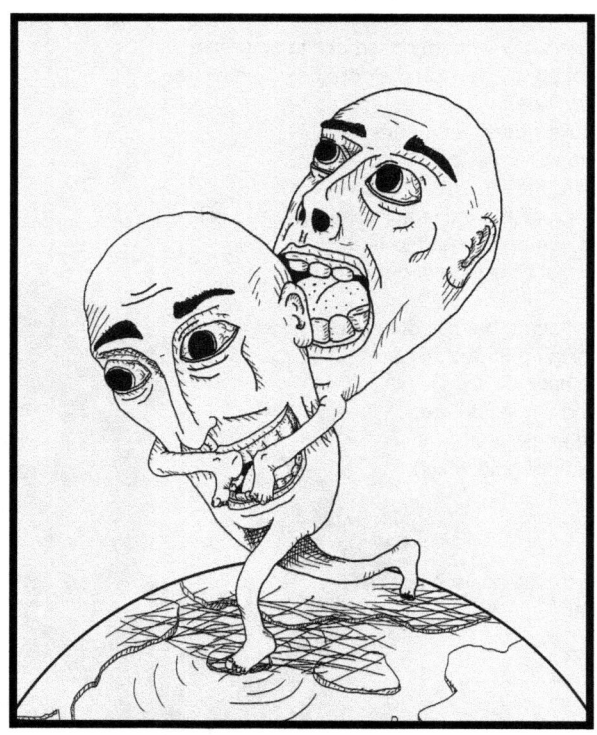

Paint Stain

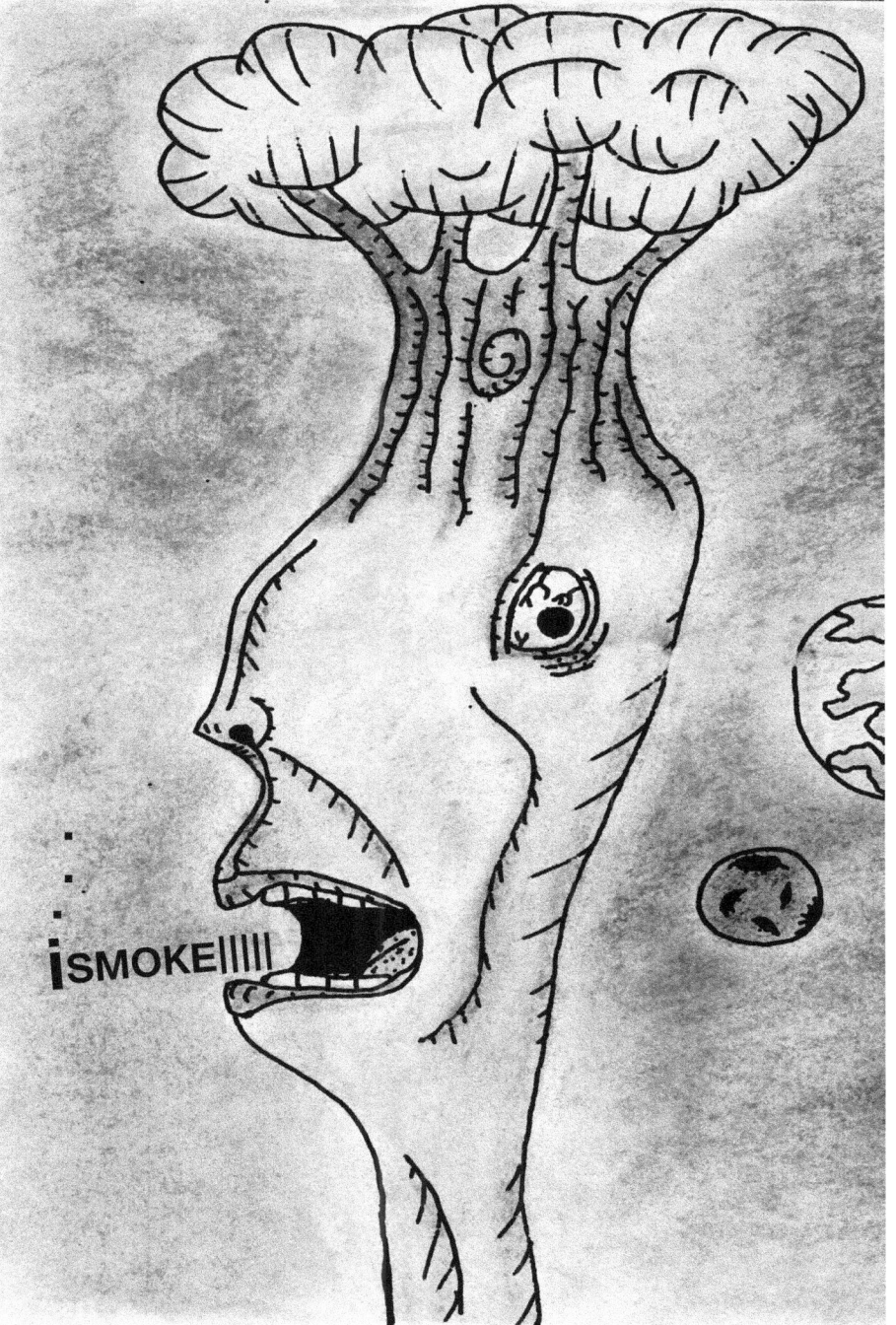

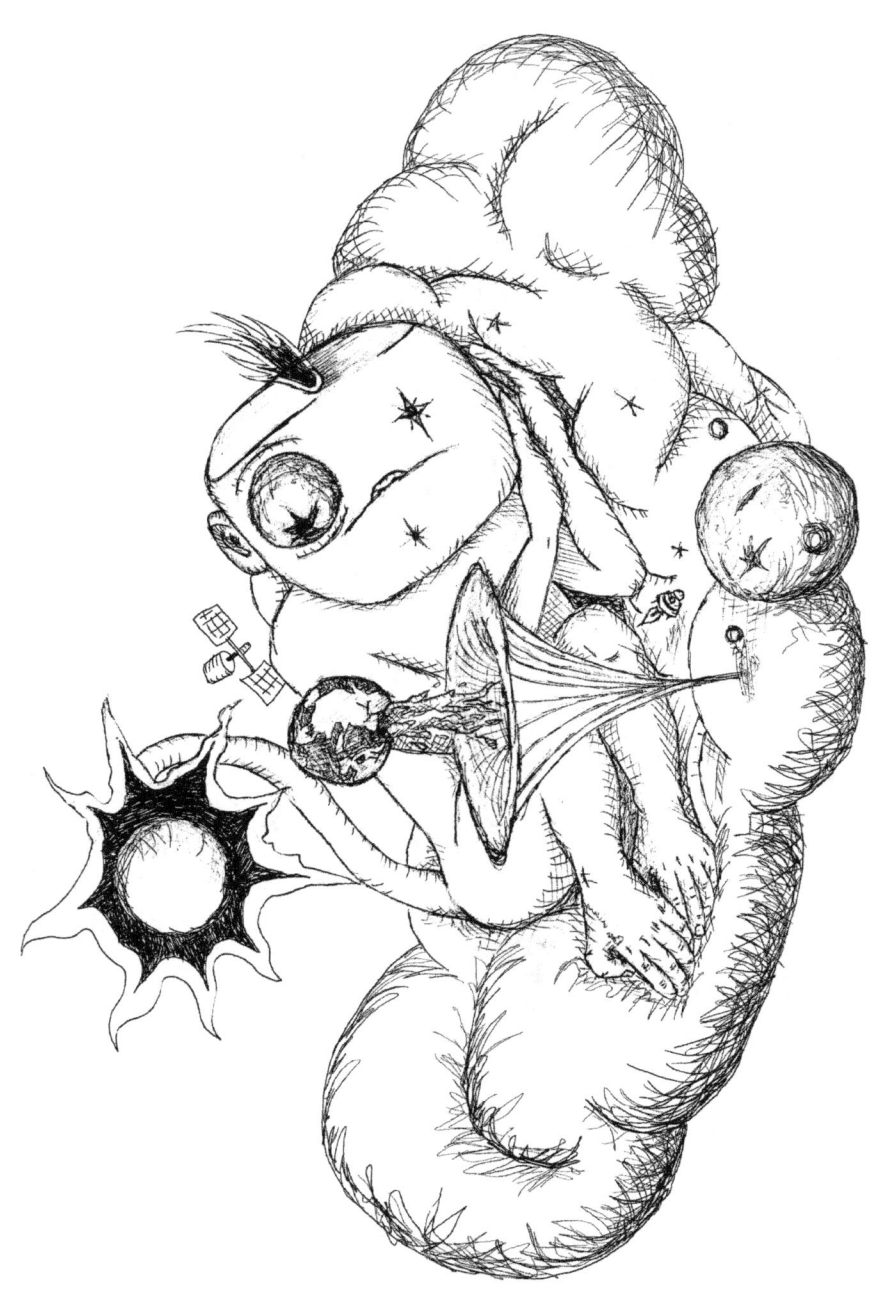

A MIDNIGHT SKY

Lying on a Dead Mans Death Bed

Alone I sat as consciousness fades,
As that sound from the earth seemed so far away.

I could not tell
whether I fell up into heaven
or down into hell.
My mind was ablaze, and I was amazed
either from the heat of the fire, or the shadows it made.

But I stayed for the snacks.
Got caught in traps I placed a few years back.
Which snapped and cracked under the pressure
of thinking of the now and not of the future.
Eating dust, from a gust,
blown in from an open window.
Now learning is slow
because with every gulp, conclude results,
that have sand and spit mixed up with it.

Calling up shame; Lend me your name,
keep me in line and my ego tamed.
Judge me with demons, or save me in the angles
of angels with wing spans. Or with fire branded
symbols
colliding with skin,
travelling on the wind towards the floors or ceilings
without even thinking;
nor breathing in, until emotions subside.
Weathered up, tried and judged
with a smudge of a fingerprint and a swab of my spit.
Full of it,
sick of it,
but I won't die from it.

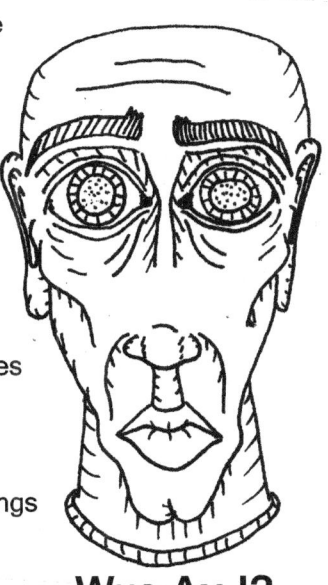

Who Am I?

HAD SOME TIME TO KILL THE SENSES

Tasting from a hole, that - if one were so bold, - could fit a fist inside.
I've always been told never stick out your tongue,
lest you lose it.
But playing with one in the dark under sheets
will have you smiling for weeks.
It speaks, then silence ensues, and now our looks
have us amused, confused and scared in the silence of night,
But content, we took a bite.

Looking at the world through holes no more than two fingers apart.
So where to start? With what I missed
in a smile, look or kiss.
Now a fist and a swollen hole, where my eyes used to go.
To the ground lies my soul, to the sky stands my mind.
Under silver lines, I'm blue,
but content for seeing you.

Hearing through holes, passed hardened skin folds and then a small drum.
We have sung with a melody and pace not heard before
in these holes I adore.
With voices deep,
and fears that creep so softly up the spine,
like the times better left in the back of our heads;
our hands are now tightly pulling each other's hair,
but content that your voice was there.

Feeling through holes no smaller than a pin; just 1000s of them, again and again
gnawing at the brain starting fires that were tamed
by nothing but the sane truth
that we both knew, fully aware.
All we could do was stare at each other
and forget the clock, as it ran to a stop, and then started anew.
but content that I held you.

Smelling through holes the size of marbles,
dumbfounded at the scent coming from your hair,
a layer of meaning,
that under this ceiling saw masculinity swoon.
Oh doom block these holes
with your winters rage, and save us from ourselves.
But let us keep what smelled so sweet,
and leave it there,
content that we inhaled the same air.

RELATIONSHIP NIRVANA

The Nattering Head that Wouldnt be Silent

Sleep, that's all my eyes ask of me.
Dark and dry, blink and keep me wired.
But I'm always tired, tired of mud under my nails
inspired by romantic fantasies of betrayal.

You'd think, or do you even have a voice,
an inner monologue all of your own,
I was shown the errors of wearing jeans and sweaters
black tie events are for the dark and enslaved.

You're crass, at last, they've taped my mouth shut,
they laughed, moistening the glue with the tip of my tongue
sucking in what little air I could, tucking in the sign around my neck
that said, I am no good.

I'm Great! slapped on the back of every shirt from my past
but this rusty axe has me doing laps around the foot of her bed.
Golden dreams, freeze framed fears, a deer caught between
a bedside lamp and a clamp, that covers both my ears.

Rain, against my windowpane,
says something sweet, nearer my dying ear.
Dreaming of a day when running away
would make life easier to bear.

We're sticking it out because we're heroes,
I figure I'd be better off with version two point zero,
but upgrades came at a cost. Accosted.
Heaven forbid, I can't pay for much at all.
With tempers wearing thin, I wonder "who the hell do I call?"

Ghost busters? Retired at fifty,
just maybe they got off lightly:
A warning slap, on the wrists,
increases when face meet fists.

Multi-tasking Octo-guy

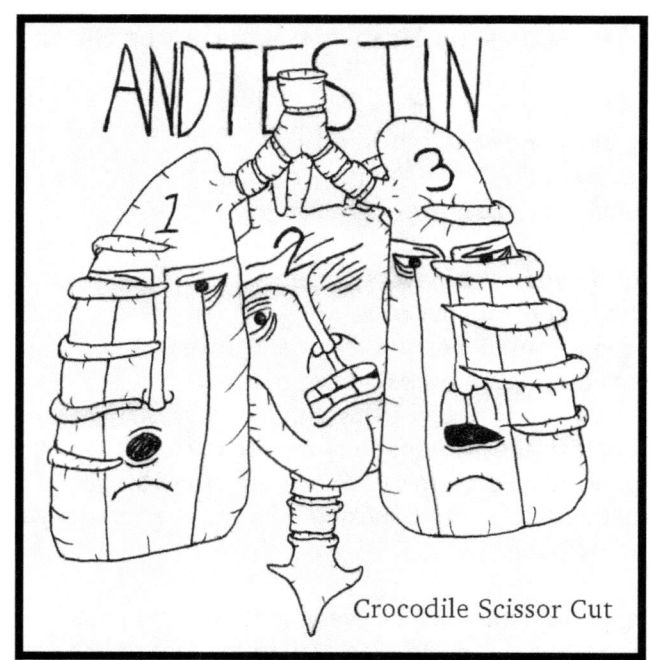

ANDTESTIN

ANDTEST

NOT MY FRAME

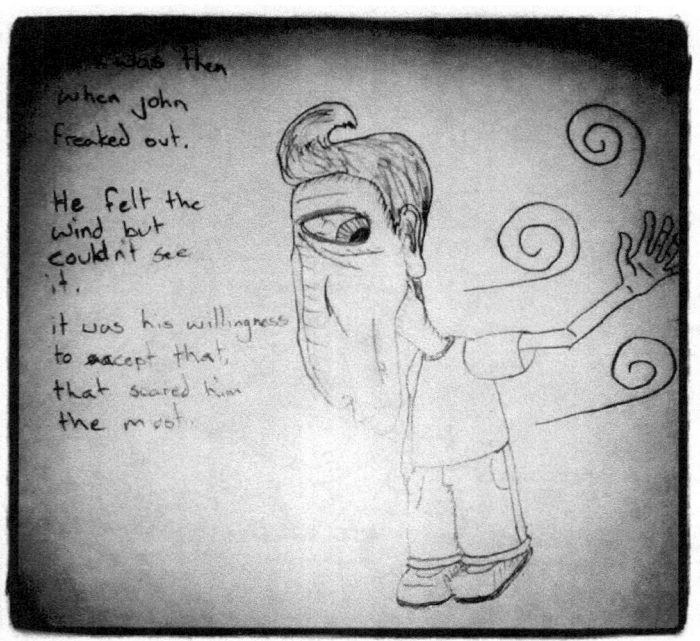

JOHN AND THE WIND

Scared little boy, Scared little man

Whats the deal?
I don't feel
you touching my skin.
I've got eyes and a mouth
but i forgot where they've been.
Lost like a basterd child
when their fathers chucked up in the bin,
in their kitchen,
glazed over eyes and a cheshire grin.

Well i keel
and i spill
my problems out my mouth and noes,
but where
is everyone
i chose to share
all this with, they all are gone.
Where did they go?
I dont know but there not here,
its clear,
my fear,
is realised in a tear.

My fingers are numb
and i am done
this obvious one sided fun.
I take a pill
and the thrill
of high subsides
then dies.
My eyes
pack up and leave
there footsteps on my sleeve.
I fail to see the resemblance,
in your disapearence and my in cohearance.
This hole exsperience has left me in tatters,
splattered on your window cill
and a feel like a broken shell,
that fell into hell.
When you set sail,
I burned for a thousand years,
but when my ears burn
thats when i learn
to turn away from what old wifes say.
Okay.
Be brave and stay
in the dark,
but that remark
I keep coming back to.
Is it true
if you're blue
you're suffocating too?

As seen in Coffee

See No Evil

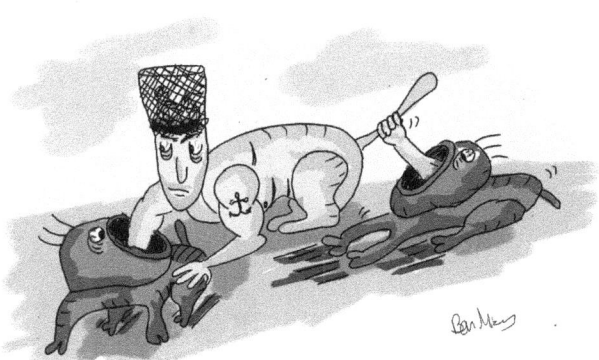

TRYING TO BE STRANGE

EARTH VS WATER

SEE WITH YOUR EYES, NOT YOUR HANDS

IN THE HAZE OF SMOKE

BEACHED BY CHOICE

I DON'T

Think Sleep

Clean Energy

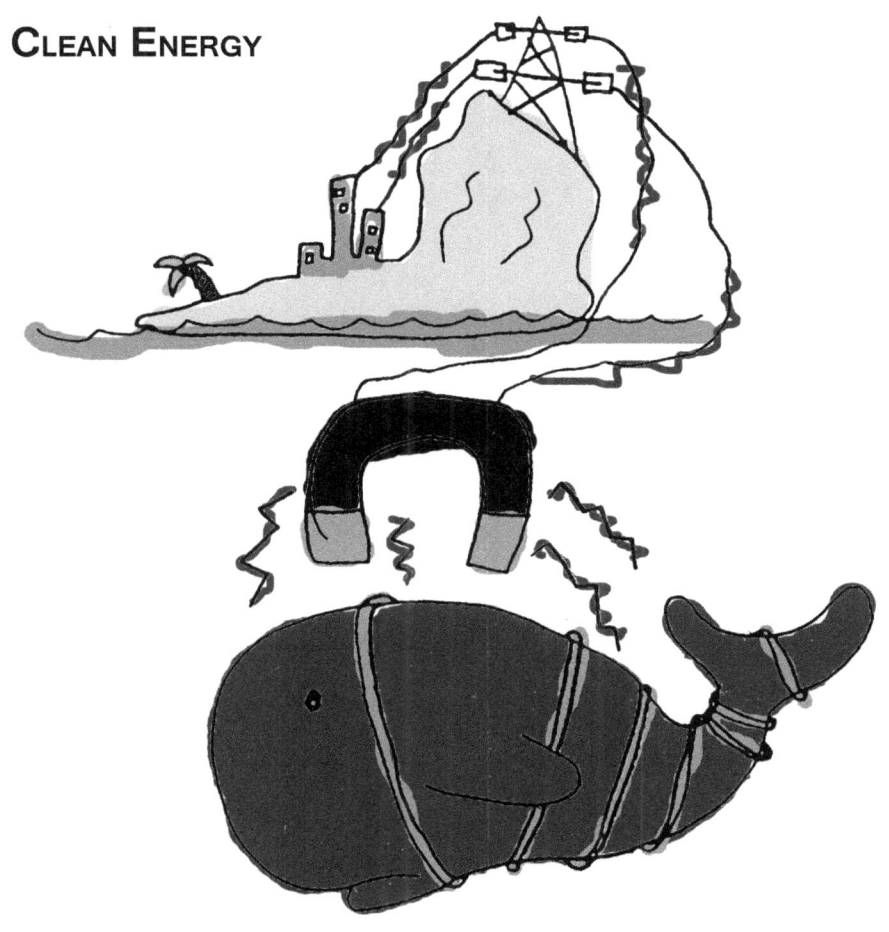

An Idea I had for clean energy.
It took me three years, after drawing this picture,
to realise that it's cruel on the whale.
I havn't as of yet come up with a better solution.